GEORGIA O'KEEFFE

CANYON SUITE

GEORGIA O'KEEFFE

CANYON SUITE

Introduction by Barbara J. Bloemink

George Braziller, New York
in association with
Kemper Museum of Contemporary Art and Design
of Kansas City Art Institute

This volume accompanies an exhibition organized by the Kemper Museum of Contemporary Art and Design of Kansas City Art Institute with generous support from Crosby Kemper and UMB Bank N.A.

For information address the publisher:
George Braziller, Inc.
60 Madison Avenue
New York, NY 10010

ISBN 0-8076-1376-2

A catalog record of this book is available at the Library of Congress

Cover Illustration: Georgia O'Keeffe, *Landscape with Crows*, 1916-18.

Designed by: Charles Davey Design Lab
Printed in Hong Kong through Mandarin Offset

CONTENTS

This volume accompanies an exhibition of Georgia O'Keeffe's watercolors shown at the following institutions:

Kemper Museum of Contemporary Art and Design
of Kansas City Art Institute
Kansas City, Missouri

The St. Louis Art Museum
St. Louis, Missouri

Denver Art Museum
Denver, Colorado

Colorado Springs Fine Arts Center
Colorado Springs, Colorado

Marianna Kistler Beach Museum of Art
Kansas State University
Manhattan, Kansas

Addison Gallery, Phillips Academy
Andover, Massachusetts

This exhibition was supported by the generosity of UMB Bank, N.A.

ACKNOWLEDGMENTS

It is altogether fitting that Georgia O'Keeffe's Canyon Suite should first be publicly exhibited in the Midwest. Throughout her life, O'Keeffe treasured her memories of growing up on the open plains of Wisconsin, claiming that, "what's important about painters is what part of the country they grow up in...I was born and grew up in the Middle West...the normal, healthy part of America...[the Midwest] had a great deal to do with my development as an artist."[1] Kansas City is the center of the heartland. It is also the site of the new Kemper Museum of Contemporary Art and Design of Kansas City Art Institute, whose opening is celebrated with this exhibition of O'Keeffe watercolors, and the home of Crosby and Bebe Kemper, whose generosity in offering these works for exhibition at the new Museum will enrich Kansas Citians' lives for generations. Sincerest thanks are extended to Crosby Kemper, Gerald Peters, the Enid and Crosby Kemper Foundation and the William T. Kemper Foundation for making this exhibition possible; and to the Board of Trustees and President of the Kansas City Art Institute for their support, guidance, and patience throughout the process of opening the museum and organizing this exhibition. Special mention must be made to Barbara Guthrie, Registrar, Pauline McCreary, Administrative Assistant, and Joe Chesla, Acting Preparator, for their patience, professionalism, and hard work. Our gratitude must be expressed to Ralph Myers, Jr. of Colorworks for his generous assistance in printing the initial museum catalog. Sincere thanks are also extended to O'Keeffe scholars Barbara Buhler Lynes and Roxanna Robinson for their scholarship and their generosity, Mark Lamster and George Braziller of George Braziller Inc., and Shirley De Walt, Executive Assistant to Crosby Kemper of UMB Bank, N.A., for her assistance. It has been a joy and rare privilege to work with all involved. Endowed funding for the William T. Kemper Curator is generously provided by the William T. Kemper Foundation Commerce Trustee.

B.J.B.

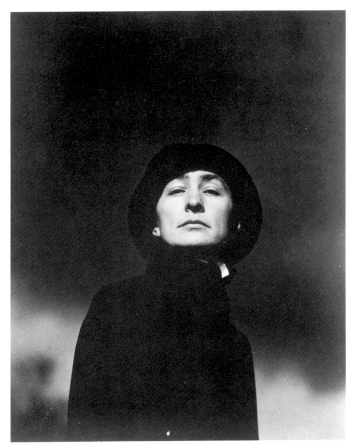

Fig. 1.
Alfred Stieglitz
Portrait of Georgia O'Keeffe, 1920
Vintage gelatin silver print
4.5 in. x 3.5 in.

INTRODUCTION

The unexpected reappearance of the *Canyon Suite*, exhibited now for the first time, provides a remarkable opportunity for close analysis of the first mature, independent phases of Georgia O'Keeffe's career. These extraordinary works on paper demonstrate O'Keeffe's incorporation of early sources, gradual rejection of academic training and experimentation with various methods of image-making, from representational landscapes and recognizable subject matter to abstracted images of natural phenomena. The twenty-eight watercolors, executed between 1916 and 1918, expand our understanding of abstraction, particularly in relation to nature, characteristic of North American painting. They also offer an alternative to contemporary work executed in major art centers such as New York and they greatly enlarge our knowledge of one of the few women artists to achieve international recognition. As such, the watercolors are among the most singular and innovative works of the time.

Too often, the "cult of personality" hampers serious consideration of an artist's work. Nowhere is this more evident than with Georgia O'Keeffe. The mythology surrounding O'Keeffe, although introduced by her husband with the artist's initial collusion, has grown through the decades to obscure thoughtful, close attention to the work. Until recently few scholars have examined the development and significance of the earlier periods of O'Keeffe's life—the influences, locations, and sources that informed her work long before she joined Stieglitz in 1918 and was carefully positioned within the New York art world.

Background
Georgia Totto O'Keeffe was born on her family's Sun Prairie, Wisconsin, dairy farm on November 15, 1887 (Fig. 2). As the second oldest of seven children she was self-

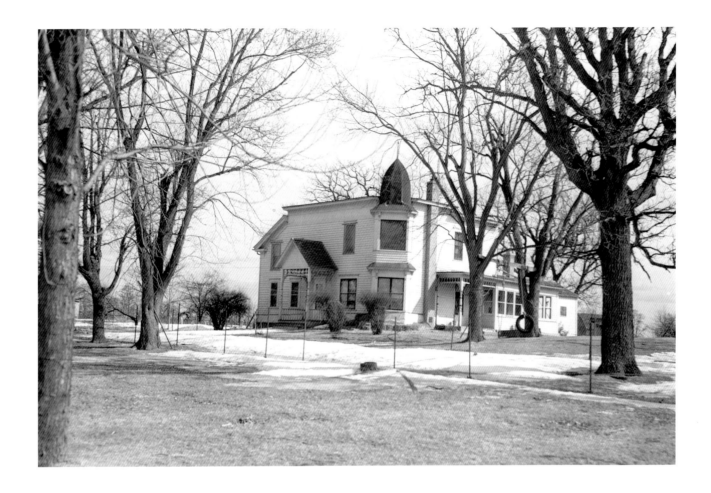

reliant and independent from an early age. As she recalled, "I had a sense of power. I always had it."[2] O'Keeffe's lifelong attachment to open landscapes grew directly from an innate response to the vast, extending plains of her mid-western birthplace. Wandering through the countryside adjacent to her father's six-hundred-acre dairy and livestock farm, she developed an appreciation for nature and an impatience with visual clutter. Later in life she declared, "Details are confusing. It is only by selection, by elimination, by emphasis, that we get at the real meaning of things."[3]

O'Keeffe's interest in art began early. As a child, she took art lessons from a local watercolorist. In 1901 she attended Sacred Heart Academy where she studied with

Fig. 2
The O'Keeffe Farmhouse, near Sun Prairie, Wisconsin. *Courtesy The State Historical Society of Wisconsin.*

Dominican nuns and won second prize in art. Her family's fortunes changed with the depression as the farm proved less and less profitable. At sixteen, the artist moved with her parents to Williamsburg, Virginia. She attended boarding school and developed a close relationship with art teacher Elizabeth May Willis, who encouraged O'Keeffe to pursue further training in art.

O'Keeffe spent the next decade moving back and forth between major urban centers where she continued her art training, and small towns where she took short-term jobs teaching art. In 1905 she enrolled in the Art Institute of Chicago, where she studied life drawing with John Vanderpoel and took top honors in his class. During the summer, O'Keeffe came down with a severe case of typhoid fever and went through a long convalescence at her family home back in Virginia. In September, 1907, O'Keeffe moved to New York City where she attended the Art Students League. Despite later attempts by promoters and art critics to portray O'Keeffe as a naive, intuitive artist, untouched by outside aesthetic influences, she was outspoken about her early art training and its extensive and varied character. In the brochure accompanying her first major exhibition, O'Keeffe identified herself first through her educational training: "I studied at the Art Institute of Chicago, at the Art Students League of New York, at Teachers College, Columbia University, at the University of Virginia. I even studied with Chase and Bellows and Professor Dow. I am sorry to say that I missed Henri."[4]

Although innovative in its attitude toward women, the Art Students League was largely based on the traditional European atelier-style academy; the emphasis of its teachers was on painting in a realistic representational manner.[5] At the League, O'Keeffe gained experience working in oil from William Merrit Chase, who demanded that his students master the medium by executing a new painting every day for a year. A flamboyant realist schooled in the Munich tradition,[6] Chase urged his pupils to integrate every part of their lives with their art—from their clothes to their gestures—a lesson O'Keeffe fully assimilated. Although she later collaborated with Alfred Stieglitz to

nurture the notion that her works grew "out of the need of personal expression of one who has never had the advantage of the art treasures of Europe and has lived life without the help of the city of Paris," this was not entirely true. Through Chase and her other early teachers, O'Keeffe was exposed to the full range of Western academic tradition in painting and sculpture. In addition, during her years in New York and Chicago, she had many opportunities to become familiar with avant-garde works reproduced in art journals. While in New York, O'Keeffe regularly visited museums and art galleries, particularly Alfred Stieglitz's renowned gallery, 291, where she and fellow students saw works by European modernist painters and sculptors, including Rodin, Picasso, Cezanne, and Matisse. During the summer of 1908 O'Keeffe attended the League's summer school session at Lake George, where students gained proficiency in painting outdoors, directly from nature.

Because of continually declining family finances and her growing disinterest with art based on the realistic imitation of nature, O'Keeffe did not return to the Art Students League. Frustrated with her past creative efforts, O'Keeffe lamented "I'd been taught to paint like other people, and I thought, what's the use? I couldn't do any better than they, or even as well, I was just adding to the brushpile. So I quit."[7] O'Keeffe temporarily gave up painting and in 1908–10 moved back to Chicago to freelance at two fashion houses, drawing lace and embroidery designs for newspaper advertisements. During this period Chicago was an important center for the Arts and Crafts and Art Nouveau movements. Many of O'Keeffe's charcoal drawings from this period contain stylized organic forms, demonstrating the influence these international art styles had on her early development.[8]

In 1909 the O'Keeffe family moved to Charlottesville, Virginia, where Georgia joined them. There she assumed her first teaching position, filling in for a few weeks for her former art teacher Elizabeth May Willis, at the Chatham Episcopal Institute. In the summer of 1912, she enrolled in Alon Bement's advanced drawing class at the

University of Virginia. Bement was a student of Arthur Wesley Dow, one of the most innovative American art educators, who felt that realism and conventionality were "the death of art" and whose teachings stressed individual expression over represen-tation.[9] Under Bement's tutelage, O'Keeffe read Dow's popular books on design, in which he emphasized the need for devising visual alphabets tailored to the individual artist's style, rather than copying from nature: "It is not the province of the landscape painter merely to represent trees, hills and houses," he commented, "but to express an emotion, and this he [she] must do by art."[10] As O'Keeffe read Dow's writing she noted, "It seemed equipment to get to work with: Art could be a thing of your own." This was a turning point in her career, as she later recalled:

> In school I was taught to paint things as I saw them. But it seemed so
> stupid! If one could only reproduce nature, and always with less beauty
> than the original, why paint at all?...I decided to give it up. I put away
> my paints and brushes. Several years later I happened to be at the
> University of Virginia.... The lecturer spoke of art as decoration: "Art,"
> he said, "consisted in putting the right thing in the right place." It gave
> me new inspiration... I was constantly experimenting but it was not until
> some time later that I made up my mind to forget all that I had been
> taught, and to paint exactly as I felt.[11]

For four summers, from 1913 to 1916, O'Keeffe taught drawing classes under Bement's supervision at the university in Charlottesville. Bement directed her to the writings of Wassily Kandinsky, the innovative publication *Camera Work*, and Jerome Eddy's book, *Cubists and Post-impressionism*, where O'Keeffe first saw abstractions of natural forms by fellow American artist Arthur Dove. Bement helped O'Keeffe get a teaching position as supervisor of art education (grades K-8) in the Amarillo, Texas, public school system. In 1914, he urged O'Keeffe (now age twenty-seven), to study directly with Arthur Wesley Dow at Columbia Teachers College in New York.

Dow's concept of teaching art education was based on "filling space in a beautiful way." He argued that artists should not strive for a picture of a flower, as "that can be left to the botanist—but [should seek] rather an irregular pattern of lines and spaces, something far beyond the mere drawing of a flower from nature."[12] Several of Dow's precepts found resonance in O'Keeffe's emerging personal aesthetic. One afternoon O'Keeffe listened in on an art class in which Dow played music and suggested that his students make quick charcoal sketches to correspond with the sounds.[13] Intrigued by this innovative method of art making, O'Keeffe sat in the hallway and tried her hand at making spontaneous drawings corresponding with the musical notes and rhythms. During the next few years, O'Keeffe would often refer to her drawings as her "music." Dow was also fascinated by Japanese painting and many of his art theories derived from Japanese-inspired principles of picture making. "The Japanese," he observed, "know of no such divisions as Representative and Decorative. They conceive of paintings as the art of two dimensions," For Dow the significance in art lay in the harmonious arrangement of light, lines, and colors. He urged students to selectively orchestrate the format and compositional elements of their work, noting that Japanese artists had already realized "a purely abstract language—a visual music" in their work—repeating a theme that is echoed throughout O'Keeffe's writings and work. Dow insisted students learn to paint using a Japanese brush, a practice which O'Keeffe followed during the next few years resulting in the transparent washes of color of the *Canyon Suite*.

While in New York, O'Keeffe and her friend and fellow student Anita Pollitzer sampled the artistic offerings of the city with regularity, particularly Stieglitz's exhibitions of Braque, Picasso, Marsden Hartley, and John Marin. By the time she left New York, O'Keeffe had purchased her own copy of Kandinsky's book, *On the Spiritual in Art*, had a subscription to *The Masses*, and was a regular reader of *Camera Work*; (over the next few years both Pollitzer and Stieglitz loaned O'Keeffe back issues). She also avidly read the satirical magazine *291*, with caricatures and drawings by Marius de

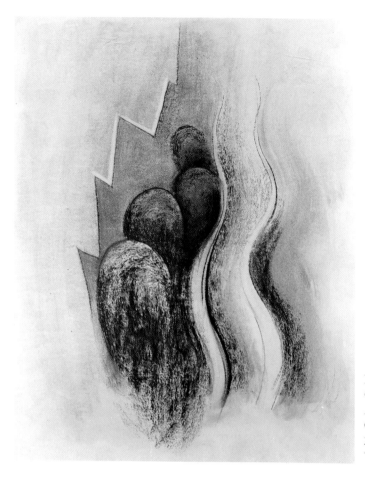

Fig. 3.
Georgia O'Keeffe
Drawing XIII, 1915
Charcoal on paper
24.5 in. x 19 in.
The Metropolitan Museum of Art

Zayas and Francis Picabia and, at Pollitzer's suggestion, she joined the National Woman's Party.[14]

In September, 1915, O'Keeffe took a one-year teaching position in Columbia, South Carolina, which she described as being "at the tail end of the earth." Fighting bouts of depression, she taught, carried on flirtations with various men, read Kandinsky for a second time, practiced the violin, and corresponded regularly with Anita Pollitzer, discussing various art and theoretical issues. She later remarked that the isolation of her time in Carolina allowed her to assimilate many of the ideas she had previously

heard. While in South Carolina, O'Keeffe painted a series of charcoal drawings based on landscapes which she sent to Pollitzer, writing, "I am afraid people wont understand and—and I hope they wont—and am afraid they will...they are at your mercy. Do as you please with them." (Fig. 3). Abandoning color, she began by drawing "things in my head that are not like what anyone has taught me—shapes and ideas so near to me—no natural to my way of being and thinking that it hasn't occurred to me to put them down."[15] Despite her insecurity at their reception she confided in Pollitzer, "I believe I would rather have Stieglitz like some thing—anything I had done—than anyone else I know of—I have always thought that If I ever make any thing that satisfies me even ever so little—I am going to show it to him to find out if it's any good."[16]

Finding herself increasingly frustrated with her past creative efforts (she noted to Anita, "I'm floundering as usual"), O'Keeffe decided to abandon everything she had been taught and find a new way of working that was uniquely hers. She later recalled:

> I can't live where I want to—I can't go where I want to—I can't do what I want to—I can't even say what I want to...I decided I was a very stupid fool not to at least paint as I wanted to and say what I wanted to when I painted as that seemed to be the only thing I could do that didn't concern anybody but myself—that was nobody's business but my own.[1]

Through December, she sat on the floor of her rooms and tried to express her feelings using only charcoal on large sheets of paper. She wrote to Pollitzer,

> Did you ever have something to say and feel as if the whole side of the wall wouldn't be big enough to say it on and then sit down on the floor and try to get it on to a sheet of charcoal paper—and when you have put it down look at it and try to put into words what you have been trying to say with just marks.[18]

16

The resulting drawings, which O'Keeffe referred to as her *Specials*, reflect the influences of Art Nouveau's organic stylization, the theories of Kandinsky and Dow, and the first evidence of the idiosyncratic visual vocabulary to which the artist would return intermittently throughout her career. This early work also demonstrates O'Keeffe's arrival at abstraction through the exploration of natural forms, a different path than that of most European artists, whose abstraction derived from Cubism. Like most of her American counterparts, O'Keeffe's abstraction was non-geometric, based directly on nature and the evocation of organic forms and atmospheric conditions. As soon as she had completed a number of these charcoal drawings, O'Keeffe packed and sent them to Pollitzer, inquiring, "Tell me—do you like my music?"

Without telling her friend, on January 1, 1916, Pollitzer took a roll of O'Keeffe's drawings to Alfred Stieglitz at his 291 gallery. This move ultimately changed the lives of both artist and gallery director. Despite the almost twenty-four-year age difference between them, Alfred Stieglitz was a natural partner for O'Keeffe. Through his influential, initiatory gallery exhibitions, Stieglitz had already played a major role in honing the art world's (as well as O'Keeffe's) impressions of what modern art could and should be. As the publisher of *Camera Work* magazine Stieglitz reproduced work by avant-garde European and American artists and printed excerpts from Kandinsky's writings equating painting to music and from the teachings of philosopher Henri Bergson, who stated that the "loftiest ambition of art" was to "contrive to make us see...things that speech is not calculated to express." (This attitude is uncannily similar to O'Keeffe's observation to Pollitzer that she made drawings and then tried to put into words what they expressed.) O'Keeffe and Stieglitz were both aware of and drawn to the American transcendentalist writing of Whitman, Emerson, and Thoreau, in which landscape was understood to be a visual correlative for subjective, emotional states. Emerson wrote, "a work of art is an abstract or epitome of the world," and observed that "Every appearance in nature corresponds to some state of mind"— sentiments O'Keeffe and Stieglitz shared.

Stieglitz was also unusual at the time for his support of women artists. Unlike many of his contemporaries, Stieglitz believed that women artists made the same rational technical decisions with respect to their work that men did; however he believed that women felt the world differently from men[19]—a concept O'Keeffe shared, at least temporarily, when she wrote about her drawings in 1916: "The thing seems to express in a way what I want it to but—it also seems rather effeminate—it is essentially a woman's feeling—satisfies me in a way..." When Pollitzer wandered into his gallery with O'Keeffe's charcoal drawings, Stieglitz was suffering from frustration with his photography and with his twenty-year marriage; and he was longing for a new challenge to energize him. Examining O'Keeffe's charcoal drawings, he realized he had found just such an impetus and exclaimed, "Finally a woman on paper!" As Pollitzer reported to O'Keeffe, Stieglitz continued, "Why, they're genuinely fine things...She's an unusual woman—She's broad minded...but she's got the sensitive emotion—I'd know she was a woman—O, Look at that line!"

In February 1916, O'Keeffe returned to New York City to take a methods class with Arthur Wesley Dow, a condition of a new teaching job in Canyon, Texas, that she would begin in September. Without her knowledge, Stieglitz hung a few of her drawings in his gallery along with works by artists Charles Duncan and René Lafferty. When O'Keeffe heard about the exhibition she rushed down to the gallery demanding that Stieglitz take her works off the walls. He convinced her to leave them up, stating "You don't know what you have done in those pictures," to which she replied "Certainly I know what I've done. Do you think I am an idiot?"[20] affirming her awareness of her drawings' originality.

Ten days later O'Keeffe returned to Charlottesville, Virginia, where she taught a session at the university and wrote regularly to Stieglitz, who was summering at his family home at Lake George.[21] In exchange for voluminous letters and copies of *Camera Work*, she sent him bundles of her latest drawings which, artist Marsden Hartley

noted, he carried everywhere. Stieglitz's encouragement and interest in her work inspired O'Keeffe to a new bout of creativity and she began to reintroduce color into her work. That fall, Stieglitz included O'Keeffe in a group exhibition at his 291 gallery and in April, 1917, he gave O'Keeffe her first solo exhibition. Exhibiting a number of the charcoal drawings and works on paper, the show resulted in O'Keeffe's sale of a charcoal drawing, *Train at Night in the Desert*, based on a theme she would return to several times in the next few years.

Canyon, Texas

In September, 1916, O'Keeffe moved to Canyon, Texas, as head of the art department at West Texas State Normal College (Fig. 4.). Although she found the Texas town of twenty-five hundred full of "ugly little buildings," O'Keeffe was immediately struck by the beauty of the landscape surrounding Canyon. She wrote Pollitzer, "It is absurd the way I love this country...I am loving the plains more than ever it seems—and the SKY—Anita you have never seen SKY—it is wonderful."[22] (Fig. 5.). In an article of 1932, a reviewer described the affinity O'Keeffe must have felt for an area where open plains extend in all directions with an almost passive horizontality: "For it seems almost without fail that the structures of her paintings adumbrate the topographical structure of this northwest Texas region which has a lean beauty, not entirely desert, and voluptuous but spacious, direct, powerful, with great sweeping areas that move uninterrupted into infinity."[23] Finding herself again in the midst of extended plains rekindled in the artist an early appreciation of the patterns and natural cycles of her agrarian childhood. For O'Keeffe, as for numerous other American artists since the eighteenth century, landscape became a form of autobiography in which she could capture the subtle changes and unrelenting, cyclical movement of time.

The untamed, uncultivated West Texas topography appealed to the artist, who noted "there is no wind—so still and so light...nothing to be afraid of—because there is nothing out there."[24] In the yellow brick building that housed West Texas State

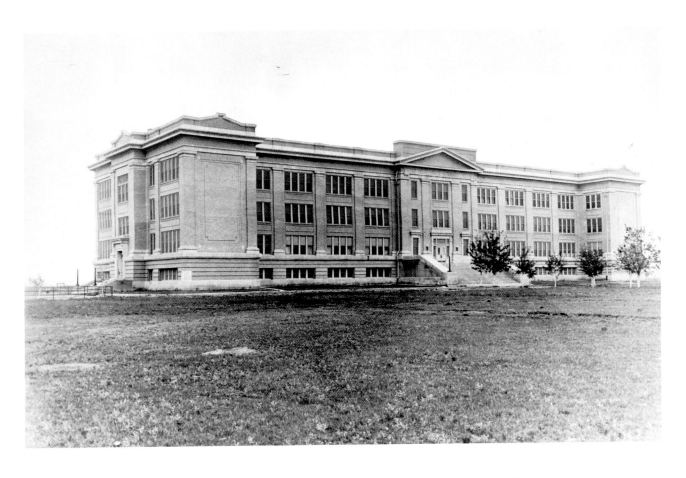

Normal College, O'Keeffe taught art theory, first-year interior decoration, and costume design to home economics majors (Fig. 6.). She ordered art books on textiles, ceramics, furniture, and Greek pottery to use in her teaching. O'Keeffe also advised the student drama club on their sets and costumes. She befriended the president of the club, an older student named Ted Reid, who shared her love for the open plains and uncultivated countryside, and together they took long walks, discussed art, and looked through past issues of *Camera Work*. Although she expressed romantic interest in several men during this period, including Reid, whom she considered marrying, O'Keeffe was essentially a loner, whose primary interest lay in her work. In a letter from this period she declared her desire to be "master of myself. I always feel sort of like a slave when I am liking any one very much."[25]

Fig. 4.
West Texas State Normal College.
Courtesy of the Panhandle-Plains Historical Museum, Canyon, Texas.

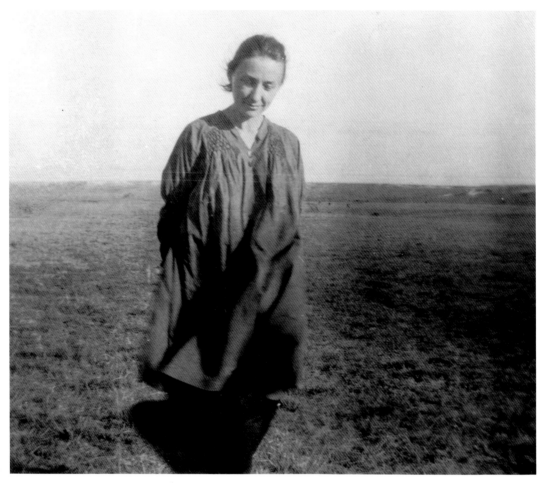

Fig. 5.
Georgia O'Keeffe
in Canyon,
Texas, c. 1917
*Courtesy
Catherine Kruger.*

During the extended period in Canyon, O'Keeffe painted over fifty watercolors, including the twenty-eight works that comprise the *Canyon Suite*. These works have been described as "sketches of inspired moments"[26]. The portability of the watercolor medium allowed O'Keeffe to work directly from nature as she meandered across the landscape, painting on whatever pieces of inexpensive paper were available. In painting the Canyon watercolors, O'Keeffe continued to work with the free gestures she initiated in South Carolina. As a result, the watercolors, like the earlier *Special* charcoal drawings, demonstrate unusual freshness and immediacy as well as offering proof of the already formed individuality of O'Keeffe's vision.

21

As O'Keeffe explored various approaches to image-making, she also experimented with degrees of abstraction. Although many people believe abstract art, by definition, has no subject matter or meaning, this is not always accurate. During the first few decades of the twentieth century, a number of artists including O'Keeffe moved toward abstraction as a visual language capable of signifying the central issues of the new modern era. These artists experimented with painting nonrepresentational works as a means of portraying ideas, emotions and metaphysical concepts that could not be depicted by using traditional imagery. In 1923, echoing earlier writings of Kandinsky, Emerson, and Dow, O'Keeffe declared: "I found I could say things with colors and shapes that I couldn't say in any other way—things that I had no words for."[27]

This impulse toward abstraction is particularly evident in O'Keeffe's Canyon watercolors in which she often varied her treatment of the medium. On one hand, she captured some landscape views, as in *Purple Mountain*, in a tight, precise, traditional and representational manner (Plate 26). In these works, the artist brushed the watercolor pigment over dry, textured paper. The paint does not penetrate the medium, but instead lies on the paper's surface; colors are isolated and contained. O'Keeffe often repeated motifs, trying to uncover their "essences." In so doing, she intermittently advanced toward abstraction by creating works whose imagery provides only fleeting allusions to the original subject matter. In *Across the Plains* (Plate 3), triangulated sections of varying ground extend across the paper and cumulus clouds gather along the tree-rimmed horizon. Because of O'Keeffe's handling of the medium, the work can be read either as illusionistic space or as flat abstract patterns. Other works from the series offer similar views with individual elements of the composition altered slightly and colors ranging freely across the paper, barely recognizable as landscapes. As she reworked images, O'Keeffe's representations often progressed from an objective view toward a more subjective, remembered *experience* of the composition. To achieve this more evocative, abstracted imagery, O'Keeffe saturated the surfaces so that colors

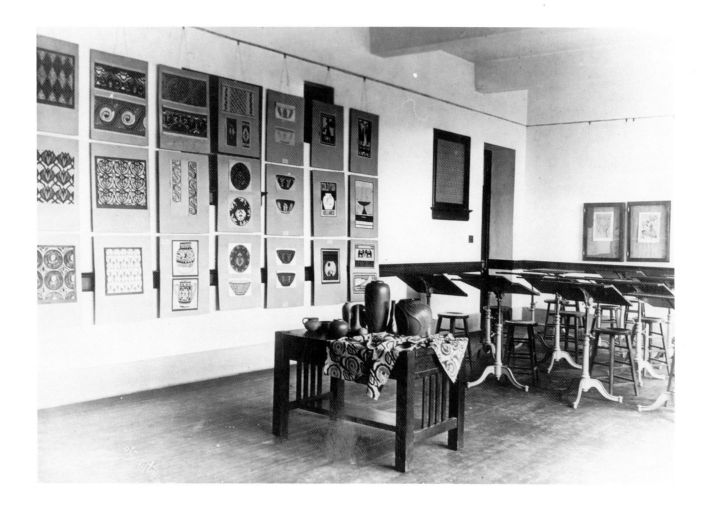

integrate with the paper fiber and blend into one another, giving the works a blurred, soft appearance. In these watercolors, the landscape appears to dissolve, as in *Dusk in the Canyon* (Plate 27) where shapes melt and blur, and details grow hazy as if seen through wavering striations of burning sunlight.[28]

In addition to southwestern landscapes, O'Keeffe repeated several other themes during these years. Limiting her palette to blue-green, red, and black, she painted an unusual series of nudes; one of the few times in her mature career that she painted figures. With one exception (Plate 5), the women are shown seated and posed against an

amorphous backdrop. To varying degrees in different works, the sitter's body is invaded by the veils of color representing the background. The blurred treatment of the nudes is reminiscent of the Rodin watercolors of nudes that O'Keeffe had seen earlier in Stieglitz's gallery.

Like predecessors such as George Inness and Hawthorn, Whitman, and Thoreau, O'Keeffe was fascinated by the image of trains, appearing like tiny mechanical beacons on the open landscape. Between 1916 and 1918, she painted a number of works on the theme of the machine invading the prairie, heralding the arrival of the machine age.[29] One of these is *Train Coming In*, (Plate 24). In several of O'Keeffe's watercolors and drawings, dust from the plains mixes with the accumulated billowing of smoke streaming from the train. The engine appears like a shimmering mirage crossing the undifferentiated plains. Within the arid, desolate land, the locomotive connotes less a destructive than an animating force and recalls Walt Whitman's lines in "Passage to India."

> I hear the locomotives rushing and roaring, and the
> shrill steam-whistle,
> I hear the echoes reverberate through the grandest
> scenery in the world...

In this verse, Whitman employs the machine as a metaphor for a higher, spiritual power, giving it an idyllic grace resembling O'Keeffe's renditions of the subject. O'Keeffe would often return from her long walks around Canyon with her clothes covered with dust. In one extraordinary *grisaille* watercolor, titled *Gray Abstraction (Train/Desert)* (Plate 23), the only evidence of former motion on the stilled landscape are the remaining curved, embryonic waves of gray, trailing against the sky. Painted with only a few strokes of the brush, the work is unusually abstract for its early date. It is a graceful, enigmatic painting, unique in early American twentieth-century art.

The spiral forms and monochromatic palette recall the South Carolina charcoal drawings O'Keeffe made a year before coming to Canyon.

Trees silhouetted against the gathering dusk provided another subject for the artist, one to which she returned several times. In one watercolor, an island of trees is isolated against an indeterminate sea of deep blue, the last rays of light catching briefly in the crown of its leaves.[30] In another (Plate 7), a single tree is ringed with light against the night sky. A linear silhouette with red and yellow dots is the only thing that distinguishes the tree from the undifferentiated background. O'Keeffe painted this watercolor on translucent paper, on top of which she collaged further layers of color, laid like leaves adding to the surface's depth. From this period, several additional watercolors resembling tree forms have been classified 'abstract portraits' by some O'Keeffe scholars. In works from this series, a large gray-brown trunk extends vertically up the picture plane. At the lower left, each trunk terminates in a large bulbous burl, in the center of which the artist added a dash of red/sepia color[31] (Plate 8). Abstract portraiture, in which artists, writers, and musicians of the era used animate and inanimate forms to convey the personalities of their friends and sitters, was common among avant-garde circles working in Paris and New York during the period between the world wars.[32] That O'Keeffe tended to correlate persons with landscapes is evident from a letter she wrote to Anita Pollitzer, describing her flirtation with a young teacher named Hansen. The myriad feelings Hansen engendered in O'Keeffe found their expression in a series of watercolors she sent to her friend in New York and a letter in which she described Hansen as "the little blue mountain with the green streak across it." At another time, Georgia O'Keeffe stated:

> There are people who have made me see shapes...I have painted portraits
> that to me are almost photographic. I remember hesitating to show the
> paintings, they looked so real to me. But they have passed into the world
> as abstractions—no one seeing what they are.[33]

A large number of O'Keeffe's Texas watercolors are devoted to the natural phenomena of light rising or fading on the open plains. Her repeated images of sun and sky celebrate the natural order of life and suggest the transcendence of time approaching eternity. Alone, with Ted Reid or some other companion, O'Keeffe spent hours at sunrise and dusk taking long walks through the countryside. As she wandered across the plains, she was astonished by the power and brilliance of Texas sunsets in which "the whole sky...[was]just blazing—and gray blue clouds were riding all through the holiness of it." In the watercolor titled *Sunset* (Plate 20), O'Keeffe captured the ultimate conflagration of the sun, its incendiary colors gradually muted by descending veils of night sky. She was particularly attracted by the evening star which hung "...high in the sunset sky when it was still broad daylight.... It was in some way very exciting to me"; and she painted a series of increasingly abstract watercolors tracing the sun as it gathers intensity before bowing beneath the horizon line.

In *Evening* (Plate 1), the ebbing fireball rests momentarily, caught between the midnight blue sky and the indigo horizon. Rainbowed hues of orange, red, sepia, purple, and gray form concentric bands around the fiery star.[34] In other watercolors, the conflagration has passed, and all that remains in the dark sky is a reduced nebula form echoing sparks of shining light and color (Plate 11). O'Keeffe caught another dramatic image of the night sky in a watercolor titled *Abstraction, Black and Blue.* (Plate 14) In the painting, bolts of lightening bisect the darkened sky as adjacent sheets of rain cascade towards the dark ground. Describing the Canyon night sky, she wrote in 1916,

> The Eastern sky was all gray-blue...and the whole thing—lit up—first in
> one place—then in another with flashes of lightning—sometimes just
> sheet lightning—and sometimes sheet lightning with a sharp bright zig
> zag flashing across it...you see there nothing but sky and flat
> prairieland—land that seems more like the ocean than anything else I
> know...[35]

26

By contrast, O'Keeffe's watercolors of the sun's rising are quietly dramatic epiphanies of light. In place of the hot red, orange, and yellow colors of the sunset, O'Keeffe chose soft gradations of blue, pink, and light purple; and she freely used the background surface as an integral part of each work's composition. In contrast to many of her contemporaries, O'Keeffe tended to use many varied and pure hues in her works on paper. The multiple variations of blues used in the watercolors recall Kandinsky's designation of symbolic meanings for particular colors. For Kandinsky, red was the color of power, it "glowed in itself." By contrast, blue represented the color of heaven, and variations in intensity and hue reflected different moods and emotional states:

> The inclination of blue to depth is so strong that its inner appeal is stronger when the shade is deeper....the ultimate feeling it creates is one of rest...In music, a light blue is like a flute, a darker blue a cello; a still darker blue a thunderous double bass, and the darkest blue of all—an organ.[36]

In *First Light on the Plains* (Plate 18), the deep fuchsia and indigo night cautiously gives way to the tentative halos of light, suggesting dawn. The tones are still deep, but are now mottled by slim reed-like breaks in the sky, through which bright light streams. As these bands of radiance expand, the sun slowly ascends. In *Sunrise* (Plate 28), the striations created by the white paper soften; and their horizontality echoes the meeting point of land and sky. The blushed aura surrounding the faintly visible sun swells outward in all directions, displacing the night. Finally, in a watercolor titled *Light Coming on the Plains* (Plate 22), O'Keeffe washed the outer perimeter of the surface with blue pigment and left the central portion of the paper untouched to suggest the diffuse dilation of light, indicating the day has begun. At the apex of the composition, the imprint of the artist's fat Japanese watercolor brush is visible. O'Keeffe loaded the sable with at least four individual colors, running pink to black from right to left. She touched the brush against the saturated paper and let

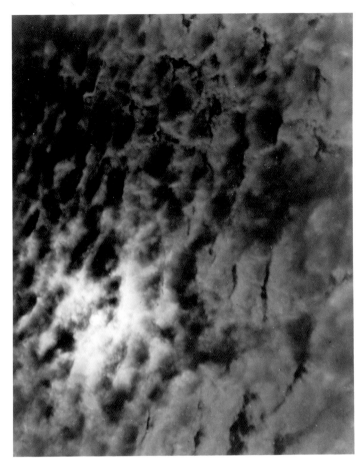

Fig. 7.
Alfred Stieglitz
Equivalent, 1926
Vintage gelatin silver print
4.625 in. x 5.625 in.

gravity and the water drag the color tones down the sheet. The result is a tour de force of watercolor technique.

Beginning in 1918, when the two were actually living together in New York, O'Keeffe and Stieglitz each created series of works in which abstracted images of nature correlated with states of mind. As O'Keeffe later observed, "Even if I could put down accurately certain things that I saw & enjoyed it would not give the observer the kind of feeling the object gave me.—I had to create an equivalent for what I felt about what I was looking at—not copy it."[37] Meanwhile, Stieglitz re-energized his career by photographing clouds which he titled *Songs of the Sky* or *Equivalent*. (Figs. 7. and 8.).

28

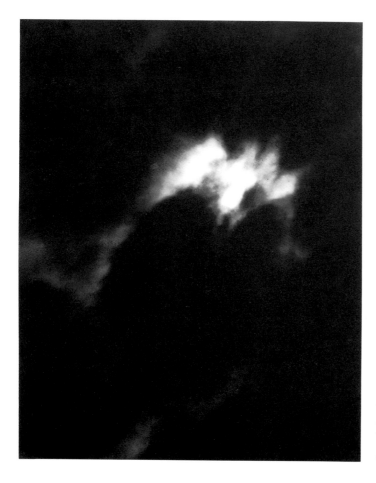

Fig. 7.
Alfred Stieglitz
Equivalent, 1926 or 1929
Vintage gelatin silver print
4.625 in. x 5.625 in.

This series was in all likelihood influenced by his newfound proximity to O'Keeffe and her work in watercolor.

When she returned to Canyon, before finally moving to New York, O'Keeffe wrote to Stieglitz regularly and sent him works as she completed them. In the Spring of 1917 Stieglitz hung a number of the works in his gallery. She was not able to come while the exhibition was open, but traveled to New York soon after it closed, spending ten days in the city with Stieglitz. He re-hung the exhibition for her and photographed O'Keeffe in front of her works. Henry Tyrrell's review of the exhibition in the May 4th *Christian Science Monitor* set the trend for how these early works would be seen for decades:

The interesting but little known personality of the artist...is perhaps the only real key....[O'Keeffe] has found expression in delicately veiled symbolism for "what every woman knows" but what women heretofore kept to themselves...the loneliness and privation which her emotional nature must have suffered put their impress on everything she does....Now perhaps for the first time in art's history, the style is the woman.[38]

Henry Tyrrell further announced that O'Keeffe's early abstractions suggest "the innermost unfolding of a girl's being, like the germinating of a flower." This and similar reviews gave the works a mysterious, exclusionary quality fostered by Stieglitz.[39] Always the promoter, Alfred Stieglitz felt O'Keeffe's art was fundamentally a revelation of her sexuality. Because his voice was so influential at the time, this opinion was quickly adopted by others as the correct approach to O'Keeffe's work. Marsden Hartley, in an article O'Keeffe hated but Stieglitz reproduced to accompany an exhibition, described her early work as being "as living and shameless private documents as exist." Hartley further confused the issue by falsely stating that the artist "lays no claim to intellectualism. She frets herself in no way with philosophical or esthetic theories—it is hardly likely she knows one premise from another."[40] Over the next few years, this correlation between the artist's sexuality and her imagery caused many critics to avoid the formal issues suggested by the work and instead concentrate on the fact that the artist was a woman. One reviewer even drew parallels between his image of O'Keeffe as an artist and his fantasy of her as a housewife: "Had she taken up the customary duties of woman...there would have been no dust under the bed, no dishes in the sink and the main entrance would always be well swept."[41] Although O'Keeffe's reaction to specific criticism is unknown, decades later she acknowledged Stieglitz's overriding influence on the reception of her work, stating:

Eroticism! That's something people themselves put into the paintings. They've found things that never entered my mind. That doesn't mean

they weren't there, but...it wouldn't occur to me. But Alfred talked that way and people took it from him.[42]

As Stieglitz worked to "market" his new find, O'Keeffe returned to Canyon, Texas, where she came down with influenza. Her pacifist attitude toward the war made her increasingly unpopular with the locals, and she never fitted in with her academic colleagues. Discouraged, she wrote Stieglitz, "I want to damn every other person in this little spot...mostly educators...the *little* things they force on me."[43] Stieglitz responded, suggesting that O'Keeffe give up teaching, move to New York and concentrate on her own work. Stieglitz offered to find financial support for her painting and he sent his young colleague, the photographer Paul Strand, to Texas to fetch O'Keeffe and bring her north. O'Keeffe agreed, however before leaving Texas, she gave twenty-eight of the Canyon watercolors to Ted Reid. Her continuing close relationship with Reid had come to be seen by some faculty members as an impropriety, so the relationship ended; however, it is indicative of her respect for Reid that she gave him such a large group of her works. The watercolors subsequently remained in Reid's family, unknown to outsiders, until they were found, wrapped in brown paper, in the garage of his granddaughter.[44]

O'Keeffe and Strand arrived in Manhattan on June 10, 1918, and within a month Stieglitz and the artist were sharing an apartment.[45] Soon after her arrival, Stieglitz continued taking photographic portraits of O'Keeffe, a project that would consume him for the next two decades. In February, 1921, Stieglitz opened an exhibition of 145 photographs, one third of which were images of O'Keeffe, some nude, some partial body fragments, which he hung in a separate section of the exhibition titled "A Woman." This was the first exhibition of Stieglitz's work in eight years, and as word spread about its contents, it drew an enormous viewing audience. As a result of Stieglitz's photographic quasi-erotic "reading" of O'Keeffe's body, the correlation between O'Keeffe's early work and her sexuality was further reinforced.

As O'Keeffe became aware of this phenomenon, she grew uneasy and wrote in anger and frustration to her friend the writer Sherwood Anderson "I guess I'm full of furies today—I wonder if man has ever been written down the way he has written women down—I rather feel that he hasn't been."[46] Over time, O'Keeffe came to express resentment at being classified as a woman artist rather than just an artist; however in the 1920s, she still shared with Stieglitz the belief that her work was the expression of something essentially female.[47] Believing that her work could perhaps be better understood by another woman, in a 1925 letter she asked Mabel Dodge Luhan to write about her work, since "a woman who has lived many things and who sees lines and colors as an expression of living—might say something a man can't—I feel there is something unexplored about woman that only a woman can explore—Men have done all they can about it."[48] In return, Luhan wrote an explicit essay that was never published, in which she declared that O'Keeffe was a mindless, malleable creature exploited by the showman, Stieglitz. Her friend, the artist Florine Stettheimer, came far closer to describing the actual symbiotic relationship between Stieglitz and O'Keeffe in a poem she wrote for her own amusement:

> He photographs
> She is naked
> he proclaims
> She has no clothes
> other than his words.
>
> Goldenbrown and autumnred
> they drop fast
> and cyclone about her
>
> She turns them
> into painted air
> rainbowhued

that whirls and swirls

and sucks him in.[49]

By 1923, O'Keeffe was writing about her own work in a conscious effort to forestall the kind of erotically charged criticism her earlier work had elicited and offer an alternative image of herself as an independent artist interested in objective reality. She decided to change the direction of her work, as she wrote Anderson, by leaving the evocative abstractions of the Canyon watercolors behind and concentrating instead on making straightforward, representational paintings:

> My work this year is very much on the ground—there will only be two abstract things—or three at the most—all the rest is objective—as objective as I can make it. ..I suppose the reason I got down to an effort to be objective is that I didn't like the interpretations of my other things—so here I am with an array of alligator pears...calla lilies...horrid yellow sunflowers—two new red cannas—some white birches with yellow leaves...[50]

As part of this process, O'Keeffe moved away from the watercolor medium and turned instead to oil painting where emphasis lies less on veils of color and more on smooth surface and finite forms. O'Keeffe's interest and commitment to work on paper waned and did not resume until the 1960s with the interest and intensity of the teens.

It is fascinating to speculate on the directions O'Keeffe's work might have taken had she not been so influenced by Stieglitz's marketing and the New York critics' reception of her early work.[51] Consciously or not, Alfred Stieglitz and O'Keeffe together conspired to forge an image of O'Keeffe that is powerful yet contradictory (see Plate 15). Their myth-making has occasionally worked against the artist, promoting notions of her as mere decorator, foisted on the public by a wily marketing genius of a husband who is credited with her spectacular rise to fame.

However, the evidence of the Canyon Suite refutes this. The watercolors are strong, significant works that stand on their own. Their importance rests on several levels. They are among the earliest examples of abstraction in the United States and therefore enlarge our understanding of the different kinds of and sources for abstract imagery. As images 'abstracted' directly from nature, they enlarge on the long tradition of American artists' special relationship with nature and the land. Painted by an artist who was a woman, the watercolors offer a vision and experience of the world different from that traditionally classified by historians as western art, and in so doing, they further expand our understanding and knowledge of the creative act. The Canyon watercolors also demonstrate the freedom of an artist in generating her own style, working outside the direct influence of the art market; and their reception reveals the tangible effect critical comments can have on an artist's work. On a wider level, the Canyon Suite watercolors enrich our understanding of O'Keeffe's oeuvre, her importance vis-a-vis her contemporaries and how her singular style originated and was transformed over her long career. The watercolors are inherently contradictory, like their creator. Painted in a fugitive medium, they combine delicate, fragile imagery with singular, even audacious self-confidence and power. In his 1963 catalog, *The Decade of the Armory Show*, Lloyd Goodrich remarked:

> From the beginning, Georgia O'Keeffe's art was a personal language...growing out of nature, yet attaining abstraction as pure as music. In her remarkable abstract creations from the late 1910s on, the concepts were completely original, the design daring and effective, the style absolutely clear-cut, yet always with a sense of enigmatic depths.[52]

Barbara J. Bloemink,
Kansas City, Missouri, 1994

NOTES

[1] Quoted in Charlotte Willard, "Portrait: Georgia O'Keeffe," *Art in America*, 51, October, 1963, p. 95

[2] Archer, Winsten. "Georgia O'Keeffe Tried to Begin Again in Bermuda," *New York Post*, March 19, 1934.

[3] Turner, Elizabeth. *Two Lives: Georgia O'Keeffe & Alfred Stieglitz* (New York: HarperCollins Publishers, 1992), p. 55. "I Can't Sing, So I Paint! Says Ultra-Realistic Artist; Art Is Not Photography—It Is the Expression Of Inner Life!: Miss Georgia O'Keeffe Explains Subjective Aspects of Her Work" *New York Sun*, December 5, 1922, p. 22.

[4] Robert Henri was a leading member of the AshCan School and a highly influential teacher at the Art Students League. Georgia O'Keeffe, "To MSS. and Its 33 Subscribers and Others Who Read and Don't Subscribe!" letter to the editor, MSS. no. 4 December 1922, pp. 17–18.

[5] After Thomas Eakins's expulsion from the Pennsylvania Academy of Art, for many years the Art Students League was the only art school in the United States where women artists were allowed to paint from nude models.

[6] Chase was invited to teach at the League after his painting, *The Jester*, was awarded a medal at the 1876 Philadelphia Centennial Exhibition. He went on to become one of the most admired and successful American painters and teachers of his generation. For further information on American artists studying in Munich see Richard West, *Munich & American Realism in the Nineteenth Century*, E.B. Crocker Art Gallery, 1978.

[7] O'Keeffe quoted in Dorothy Seiberling, "Horizons of a Pioneer," *Life* magazine, March 1, 1968, p. 50.

[8] Peters, Sarah Whitaker. *Becoming O'Keeffe: The Early Years* (New York: Abbeville Press 1991). O'Keeffe returned to commercial design several times in her career including in 1916 when she designed a decorative Art Nouveau-style frieze drawing for the contents page of Vanity Fair magazine, and in 1939 when she visited and painted in Hawaii as the guest of the Dole Pineapple Company, for whom she executed a painting of a pineapple for corporate advertising. Among other projects, she is credited with designing the commercial logo used for a number of years on Little Dutch Girl cleaning products.

[9] Lisle, Laurie. *Portrait of An Artist: A Biography of Georgia O'Keeffe.* (Albuquerque: University of New Mexico Press, 1986), p. 50. Dow's design-theory textbook, *Composition*, printed in 1913, was very popular and was re-printed in numerous editions by 1938.

[10] Dow, Arthur Wesley. *Composition*, (New York: Baker and Taylor, 1913), p. 32.

[11] "I Can't Sing, So I Paint! Says Ultra-Realistic Artist; Art is Not Photography—It is the Expression of Inner Life!: Miss Georgia O'Keeffe Explains Subjective Aspects of Her Work," *New York Sun*, December 5, 1922, p. 22.

[12] *Composition*, op. cit., p. 62.

[13] This incident is sometimes stated as taking place at the University of Virginia in 1912. However, in *Some Memories of Drawings*, edited by Doris Bry (New York: Atlantis Editions, 1974), O'Keeffe recalled this incident as taking place at Columbia University Art Department. Both Dow and Bement taught at Teachers College in New York and either one could have been teaching this course. Since Bement was a student and close follower of Dow, it is probable that he used the same exercises in instructing his students. The actual incident could have taken place in either Virginia or New York but since there is no recorded quotation by O'Keeffe correlating her work to music until after 1914, it is likely that this incident took place in New York. Author's conversation with Barbara Buhler Lynes, June 29, 1994.

[14] O'Keeffe maintained her membership in the party for decades and, at Pollitzer's request, she addressed a dinner sponsored by the National Woman's Party in Washington DC. in 1926.

[15] Alfred Stieglitz. *Georgia O'Keeffe: New Paintings* (New York: An American Place, 1937).

[16] Clive Giboire, ed. *Lovingly, Georgia. The Complete Correspondence of Georgia O'Keeffe and Anita Pollitzer*, (New York: Simon & Schuster, 1990), October, 1915, p. 46, 48.

[17] Georgia O'Keeffe. *Georgia O'Keeffe* (New York: Penguin Books, 1985) opposite plate 1.

[18] IBID, November, 1915, p. 92

[19] Norman, Dorothy. *Alfred Stieglitz: Introduction to an American Seer*, (New York: Duell, Sloane & Pierce, 1960) p. 136–8.

[20] Pollitzer, Anita. *A Woman on Paper* (New York: Simon & Schuster, 1988) p. 134. Variations of this conversation were recounted over the years by both Stieglitz and O'Keeffe.

[21] The Stieglitz-O'Keeffe correspondence is stored at Beinecke Rare Book and Manuscript Library at Yale University. Under the terms of O'Keeffe's will it is not accessible to be read until the year 2011.

[22] Giboire, op. cit. Letter of Sept. 11, 1916 p. 184.

[23] Hunter, Vernon. "A Note on Georgia O'Keeffe" *Contemporary Arts of the South and Southwest*, Nov./Dec., 1932.

[24] Giboire, op. cit. Letter of October, 1916, p. 208.

[25] Letter dated September 12, 1917. For further discussion, see Roxanna Robinson, *Georgia O'Keeffe: A Life* (New York: Harper & Row, 1989), p. 190.

[26] David Turner introduction, *Georgia O'Keeffe Works on Paper* (Museum of New Mexico Press, 1985) p. 10.

[27] O'Keeffe, Georgia. *Georgia O'Keeffe* (New York: Viking Press, 1976), facing plates 12 and 13.

[28] Although not part of the Canyon Suite, O'Keeffe concurrently painted at least four additional works in a series titled Pink and Green Mountains (various collections including the Spencer Museum of Art and the Edward Lenkin and Katherine Meier collection) in which the landscape is reduced to simple bands of color, separated only by lines created by the paper surface.

[29] The Canyon Suite incudes two works that probably refer to trains on the open plains, the subtle *Train Coming In* and *Gray Abstraction(Train/Desert)*. Other works from this series include one in a private collection, another at the Amarillo Art Center and one at the Metropolitan Museum of Art. For further illustrations see Barbara Haskell, Georgia O'Keeffe, *Works on Paper* (Santa Fe: Museum of

Fine Arts, 1985), plates 5 and 6. For further discussion of the phenomenon of trains invading the North American landscape in art see Leo Marx, *The Machine in the Garden: Technology and the Pastoral Ideal in America* (London: Oxford University Press, 1964). For information on the machine age see the work of Charles Sheeler, Charles Demuth and the exhibition catalog *The Machine Age in America* (Harry N. Abrams, Inc., New York, 1986) for the exhibition of the same name organized by the Brooklyn Museum in 1986 .

[30] This work is in the collection of Marc Carliner and is reproduced in Haskell, op. cit., *Works on Paper*, Plate 16.

[31] One work, *Tree*, remains in the Canyon Suite; another, measuring 9" x 12" was in the collection of Sid Deutsch Gallery, New York. There is disagreement among O'Keeffe scholars about the correct alignment of the watercolors in this series and it remains problematic. According to Barbara Buhler Lynes, O'Keeffe in her Abiquiu records referred to the works as vertical. O'Keeffe's dealer, Edith Halpert, also recorded and published the works vertically. In the 1985 *Works on Paper* exhibition at the Santa Fe Museum, a watercolor titled "Portrait W" was reproduced horizontally (Plate 14), and the horizontal alignment is favored by Charles Eldredge and Eleanor Campanegro. O'Keeffe herself often stated that a good design could be displayed in any direction.

[32] The works in the Canyon Suite were given titles by Charles Eldredge and Gerald Peters. O'Keeffe would have seen object-portraits by artists including Francis Picabia and Marius De Zayas and read Gertrude Stein's word-portraits of her friends in Stieglitz's *Camera Work* magazine; however there is little evidence that she consciously created this watercolor (or the similar one *Portrait W, No 1*, in the collection of the Sid Deutsch Gallery, [Haskell, op. cit., Plate 14]) as a portrait. More research is needed on portraiture in O'Keeffe's work. For further discussion on avant-garde portraiture during the era, see Barbara Bloemink, *Friends and Family: Portraiture in the Work of Florine Stettheimer and Her Circle* (The Katonah Museum of Art, 1993). See also the work of Arthur Dove, Charles Demuth, Virgil Thomson, Florine Stettheimer, and Marsden Hartley.

[33] O'Keeffe in *O'Keeffe* (New York: Penguin Books, 1985), opposite Plate 55.

[34] There are at least five other watercolors in the series titled Evening Star which correspond with this work from the Canyon Suite, although they are more schematic and simplified in their treatment and composition. In several of these works the imagery is reduced to four or five bands of color. In each work, the circular orb of the sun sits against the horizon line. See Haskell, op. cit., plates 18–22.

[35] Letter to Anita Pollitzer dated September 11, 1916, quoted in Robinson, p. 161.

[36] Quoted in Peters, op. cit., p. 99.

[37] Georgia O'Keeffe, letter to unknown person, March 21, 1937, Beinecke Rare Book and Manuscript Library, Yale University, quoted in Eldredge, p. 171. Although generally O'Keeffe was motivated by visual stimuli, on occasion the impetus came from other senses such as the haunting, rhythmic lowing of cows under the Texas evening skies.

[38] Quoted in Lisle, op. cit., pp. 77–80.

[39] Quoted in Lynes, Barbara Buhler. *O'Keeffe, Stieglitz and the Critics* (University of Chicago Press, 1991), pp. 165–169. First published by Tyrrell in the *Christian Science Monitor*, 1916 and 1917.

[40] Hartley, Marsden. "Georgia O'Keeffe" from the O'Keeffe catalog, *An American Place*, 1936. Late in life, O'Keeffe herself continued to complicate and evade the issue of the influences on her work. She resisted readings and intellectual analyzes of her work and although she borrowed freely from a number of sources she never admitted to her works' eclecticism. O'Keeffe also avoided any discussion of the sexual or erotic content of her work. Although she herself acknowledged that since she was a woman, her work might reflect a female sensibility, she refused to allow her gender to be essentialized to only its erotic content as perceived by male observers. For further discussion of this see Barbara Buhler Lynes, op. cit., and Anna Chave, "O'Keeffe and the Masculine Gaze," in *From the Faraway Nearby: Georgia O'Keeffe as Icon* (Reading, Mass.: Addison-Wesley Publishing Company), pp.29–42.

[41] Alexander Brook, "February Exhibitions: Georgia O'Keeffe" *The Arts*, Feb. 1923, pp. 130–1.

[42] Dorothy Seiberling. *The Female View of Erotics*, p. 54 quoted in Barbara Buhler Lynes, op. cit., p. 158.

[43] Letter from O'Keeffe to Stieglitz, Sept 4, 1916. O'Keeffe papers, Beinecke Library, Yale University.

[44] For the most reliable discussion of O'Keeffe's relationship with Reid, see Roxanna Robinson, *Georgia O'Keeffe: A Life* (New York: Harper & Row, 1989). According to Robinson, several faculty ladies questioned the propriety of the student/teacher relationship and approached Reid, declaring that if he did not terminate the relationship with O'Keeffe he would not receive his diploma. Not wanting to create further problems for O'Keeffe, Reid stopped seeing the artist.

[45] When Stieglitz's divorce became final in December, 1924, he and O'Keeffe married.

[46] Cowart, Sept. 1923, p. 174.

[47] Lynes, Barbara Buhler. "Georgia O"Keeffe and Feminism: A Problem of Position" in *The Expanding Discourse: Feminism and Art History*, Norma Broude and Mary D. Garrard eds. (New York: Harper Collins, 1992), p. 437. Although interested in women's issues, O'Keeffe was clearly more interested in aesthetic concepts involving her work. In an interview with the editor of the *New Masses* in 1930 she stated, "I am interested in the oppression of women of all classes...though not nearly so definitely and so consistently as I am in the abstractions of painting. But one has affected the other....I am trying with all my skill to do painting that is all of a woman, as well as all of me." This statement was published in an article by Gladys Oaks in the *New York World*, March 16, 1930, sec. 1, p. 3 and was quoted in Sharon Udall, "Beholding the Epiphanies" in Christopher Merrill and Ellen Bradbury, *From the Faraway Nearby: Georgia O'Keeffe as Icon* (Reading, Mass.: Addison-Wesley Publishing Company, 1992). p. XX

[48] Cowart, op. cit., letter 34, p. 180.

[49] Florine Stettheimer. *Crystal Flowers* (privately published, 1949), p. 53.

[50] *Georgia O'Keeffe: Art and Letters*, Cowart, Hamilton and Greenough, letter 30, dated 11 Feb. 1924, p. 176.

[51] Lynes, Barbara Buhler. *From One Far Nearby: Georgia O'Keeffe as Icon* (Reading, Mass: Addison-Wesley Publishing Company); and Lynes, Barbara Buhler. *Georgia O'Keeffe* (N.Y.: Rizzoli Publishing Company, 1993).

[52] Catalog for the Whitney Museum of American Art.

PLATES

Plate 1
Evening
11.5 in. x 8.5 in.
Property of the Enid and Crosby Kemper Foundation

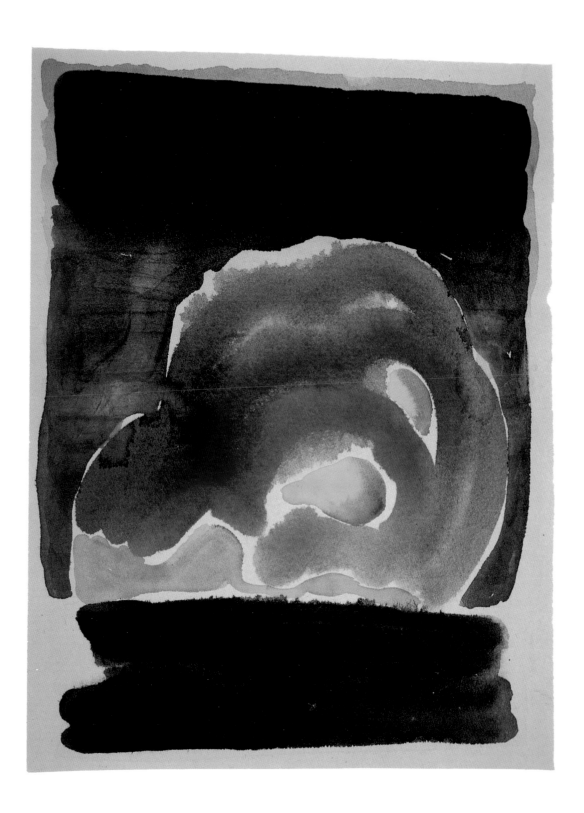

Plate 2
Landscape
8.5 in. x 11.5 in.
Property of the Enid and Crosby Kemper Foundation

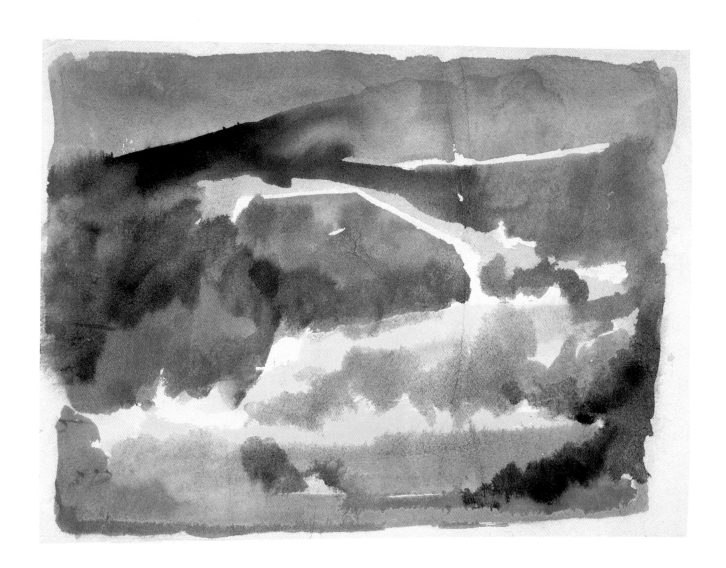

Plate 3
Across the Plains
10.25 in. x 14.75 in.
Property of the Enid and Crosby Kemper Foundation

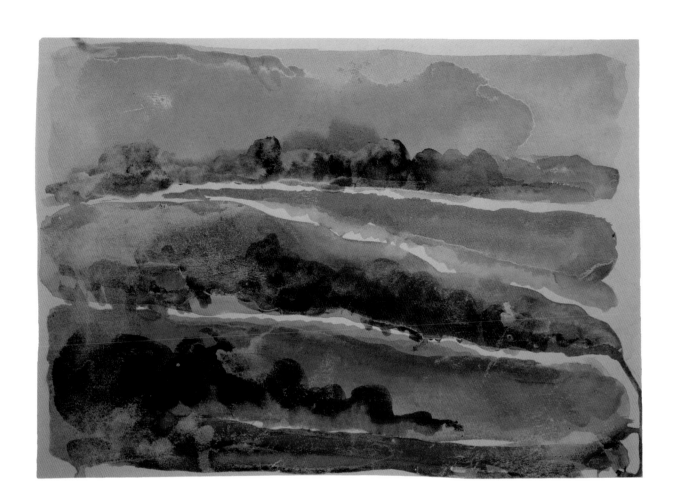

Plate 4
Sunrise
10.5 in. x 7.5 in.
Property of the Enid and Crosby Kemper Foundation

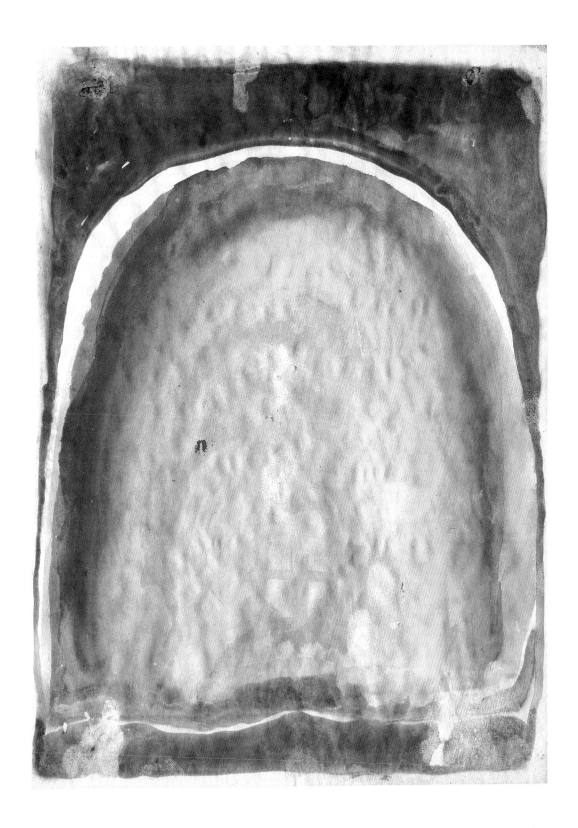

Plate 5
Standing Nude
12 in. x 8 in.
Property of Bebe and R. Crosby Kemper

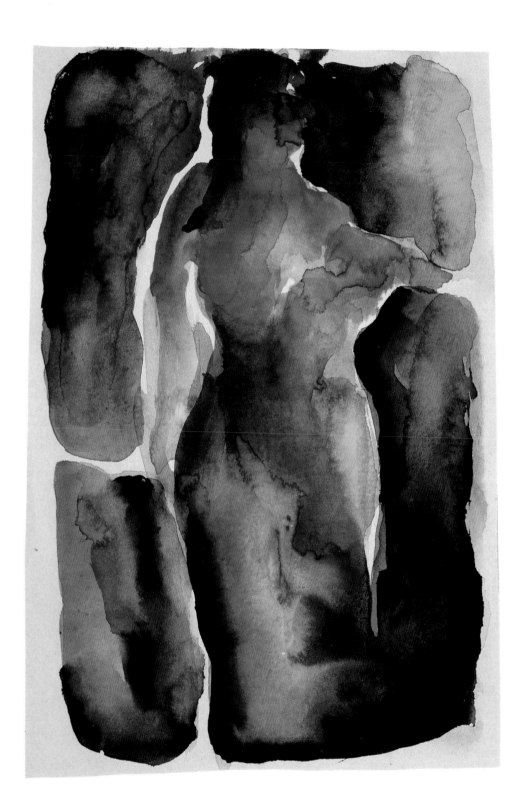

Plate 6
Abstraction, Green & Red
9.5 in. x 12.5 in.
Property of the Enid and Crosby Kemper Foundation

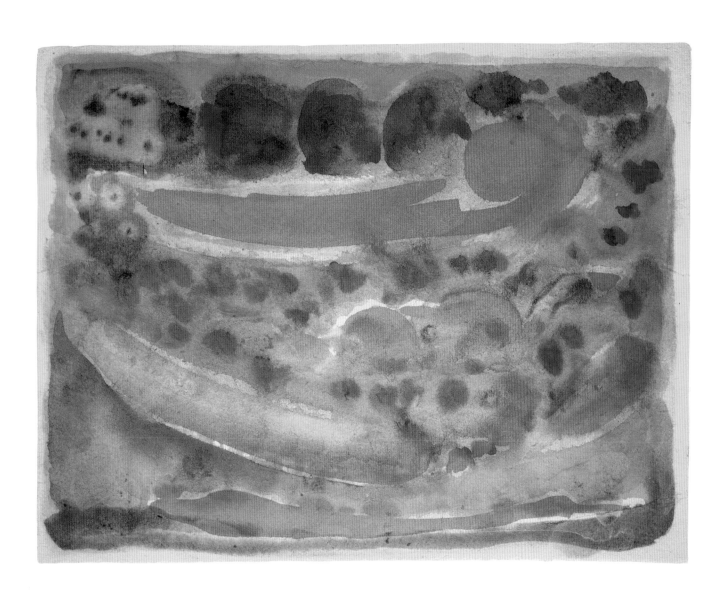

Plate 7
Abstraction, Dark
11.25 in. x 10.25 in.
Property of Gerald and Kathleen Peters

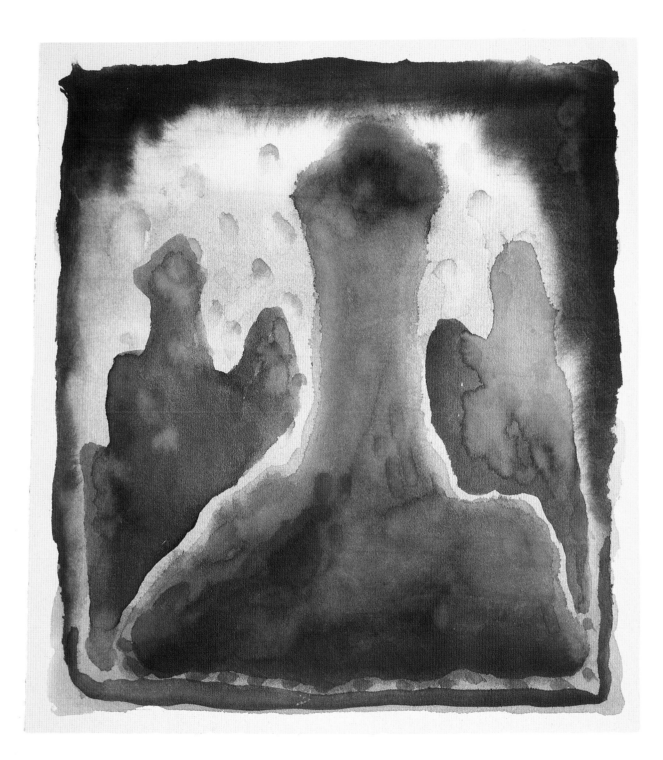

Plate 8
Abstraction
9.5 in. x 12 in.
Property of the William T. Kemper Foundation

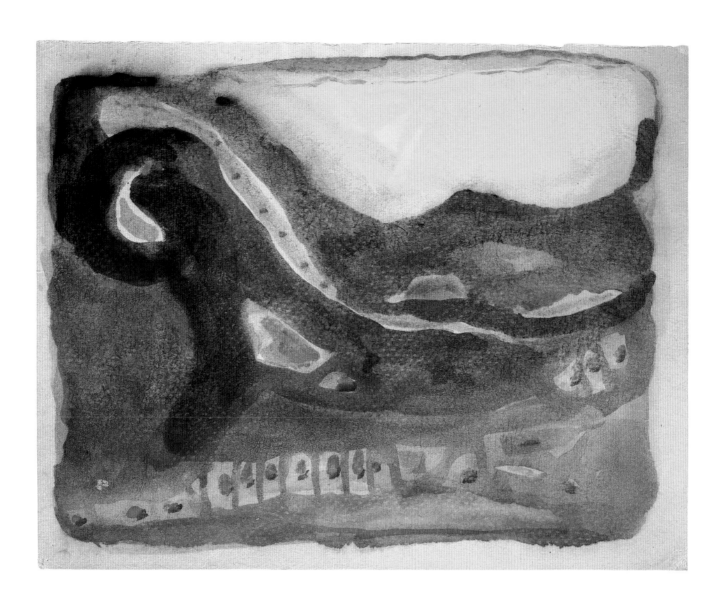

Plate 9
Tree
15.25 in. x 10.75 in.
Property of the William T. Kemper Foundation

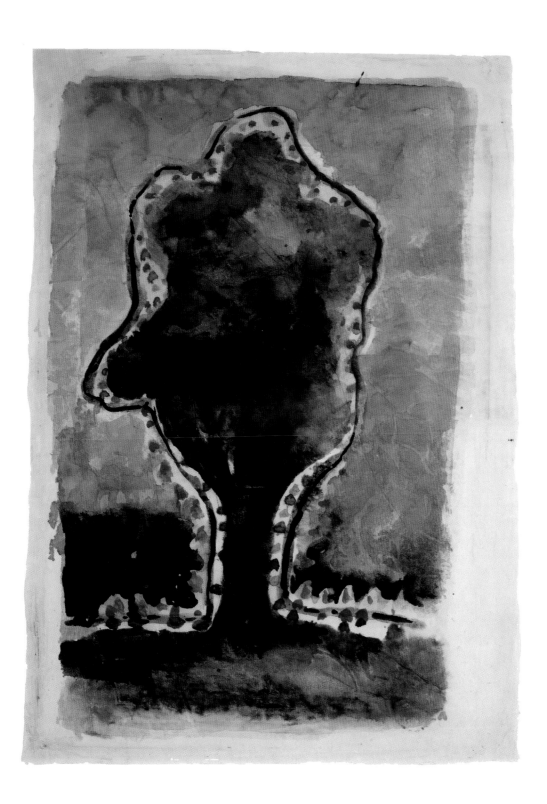

Plate 10
Portrait W
8.5 in. x 11 in.
Property of the William T. Kemper Foundation

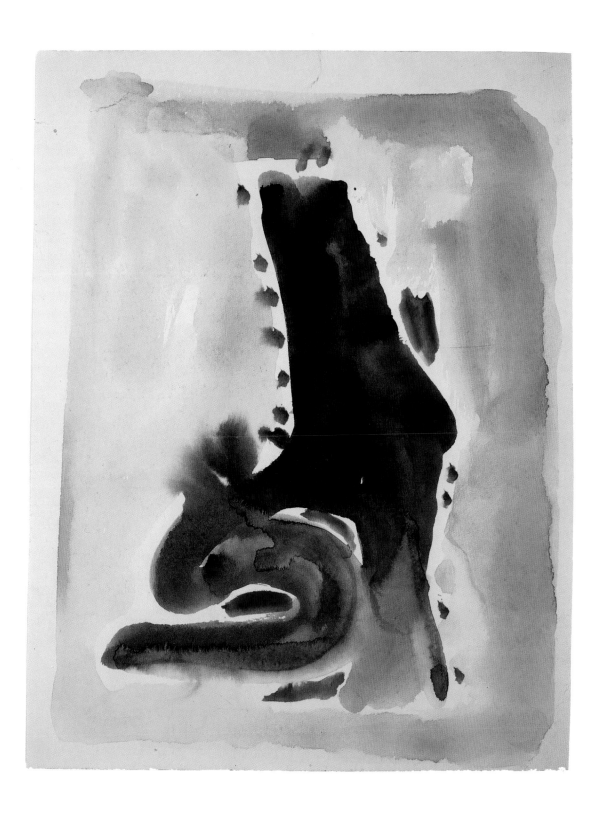

Plate 11
Canyon Landscape
9 in. x 12.25 in.
Property of the William T. Kemper Foundation

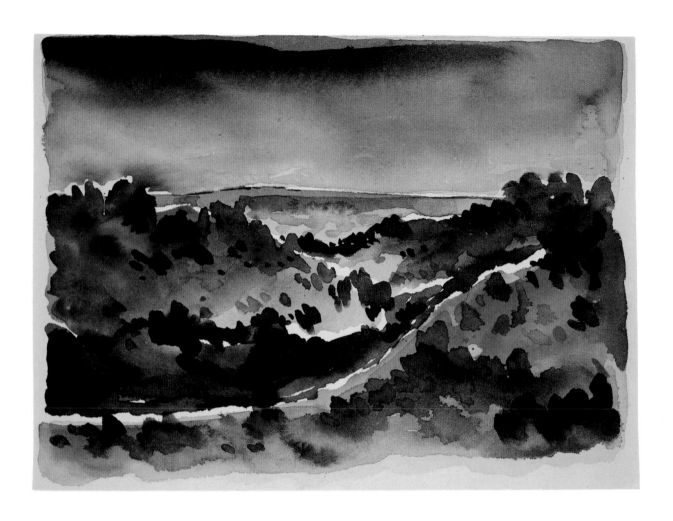

Plate 12
Abstraction
12 in. x 9 in.
Property of the William T. Kemper Foundation

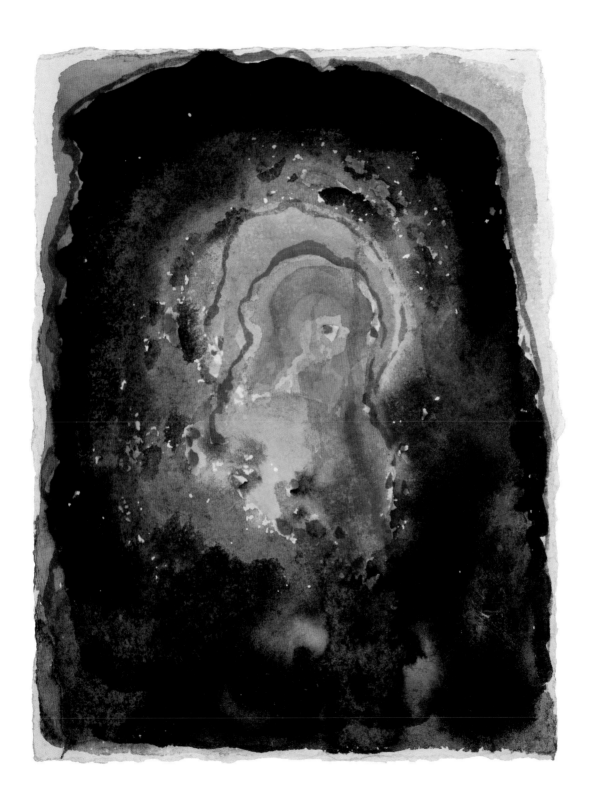

Plate 13
Blue Hills
8.75 in. x 11 in.
Property of Gerald and Kathleen Peters

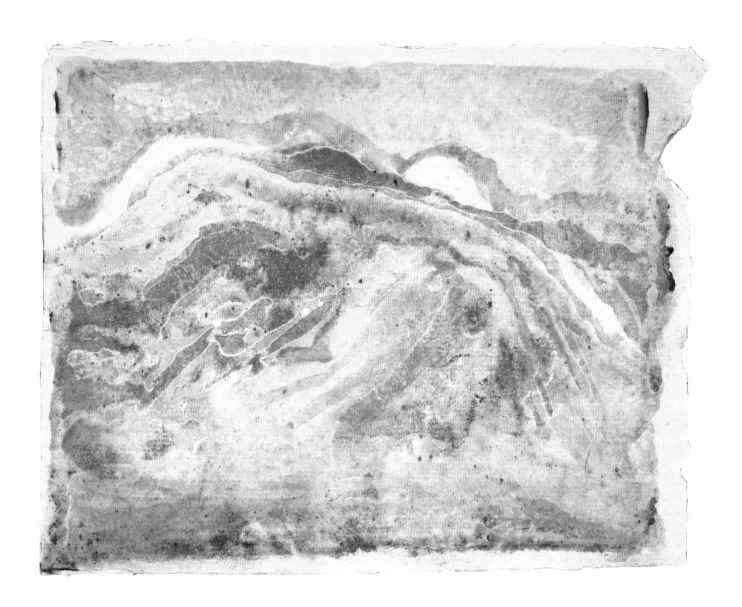

Plate 14
Abstraction, Black & Blue
12.25 in. x 10.25 in.
Property of Bebe and R. Crosby Kemper

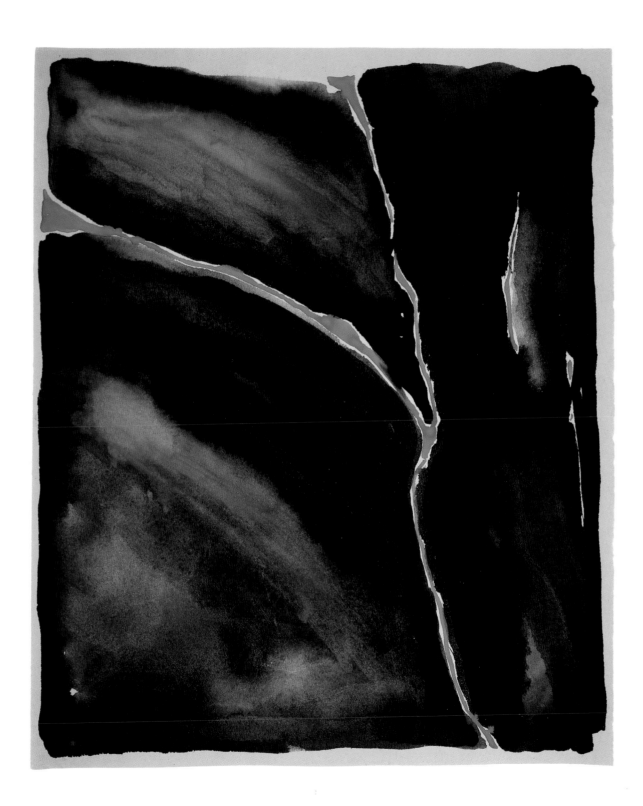

Plate 15
Abstraction, Sunset
10.75 in. x 9.5 in.
Property of the William T. Kemper Foundation

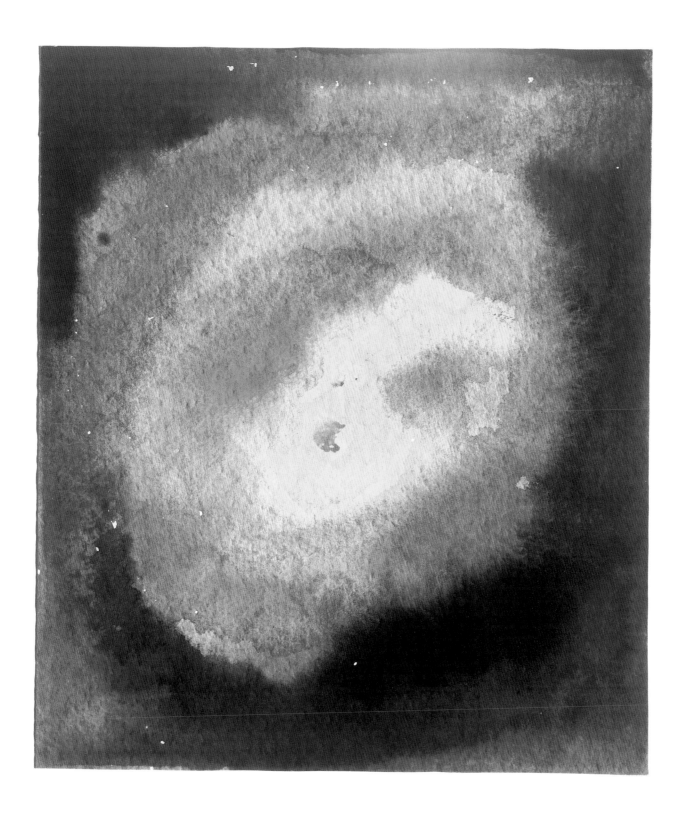

Plate 16
Abstraction, Pink & Green
7 in. x 10.5 in.
Property of the Enid and Crosby Kemper Foundation

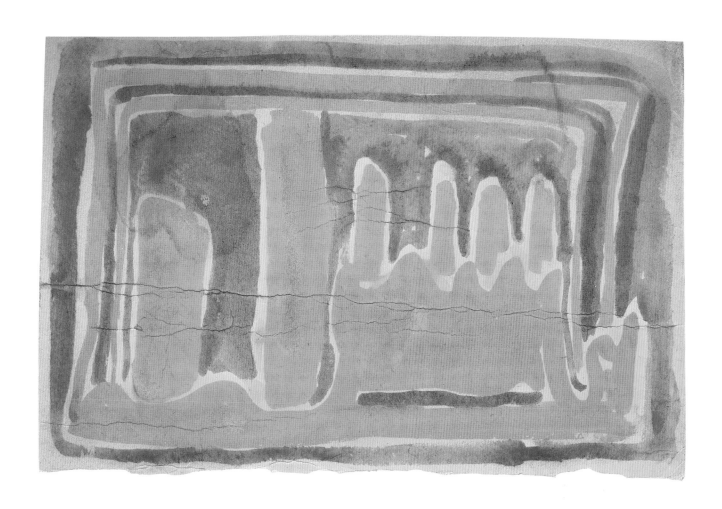

Plate 17
Red House / Fence & Door
10.5 in. x 7.5 in.
Property of Gerald and Kathleen Peters

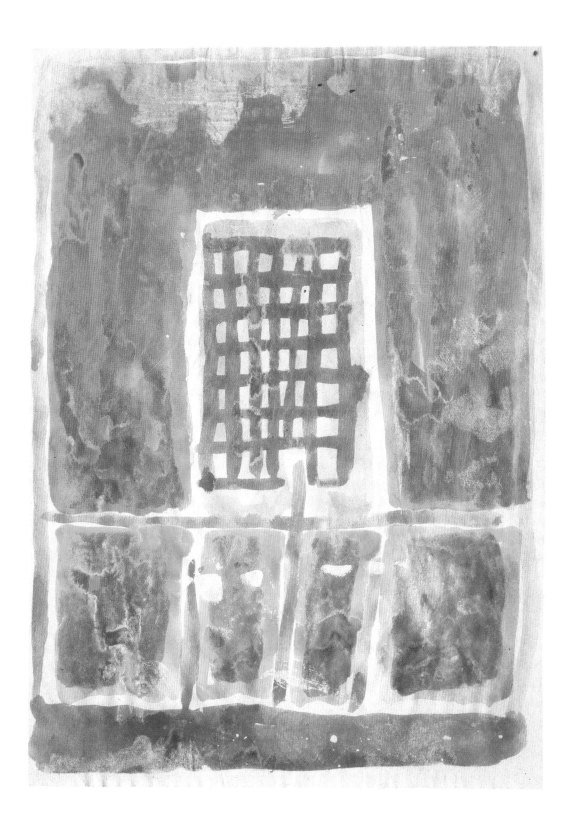

Plate 18
First Light Coming on the Plains
12.5 in. x 9.5 in.
Property of the Enid and Crosby Kemper Foundation

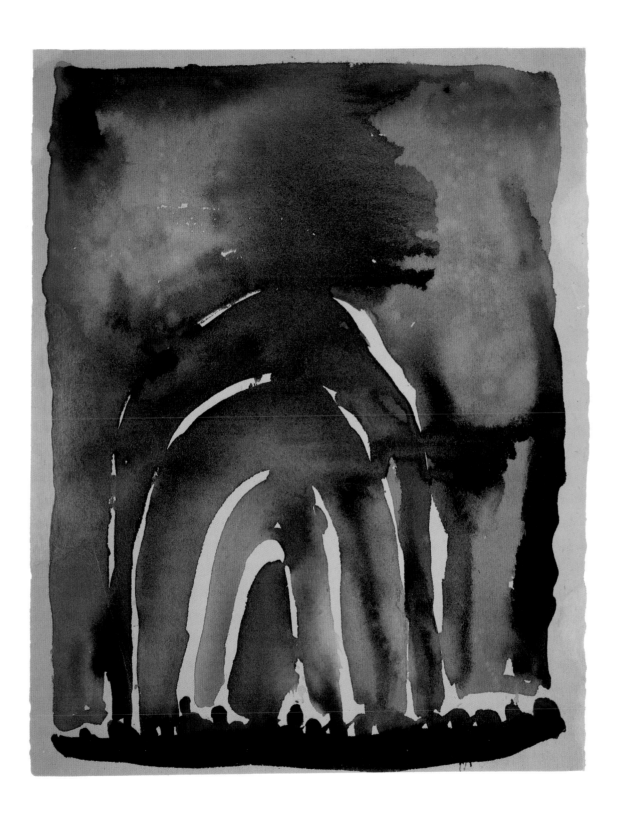

Plate 19
Landscape with Crows
7.5 in. x 11 in.
Property of Bebe and R. Crosby Kemper

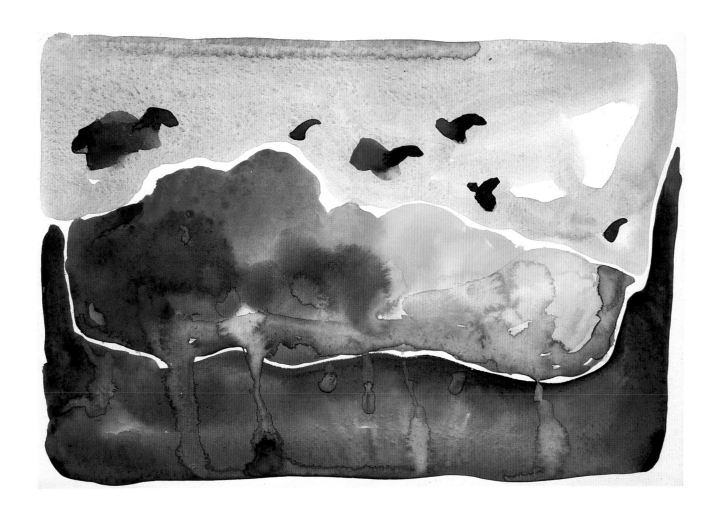

Plate 20
Sunset
11.5 in. x 8 in.
Property of Bebe and R. Crosby Kemper

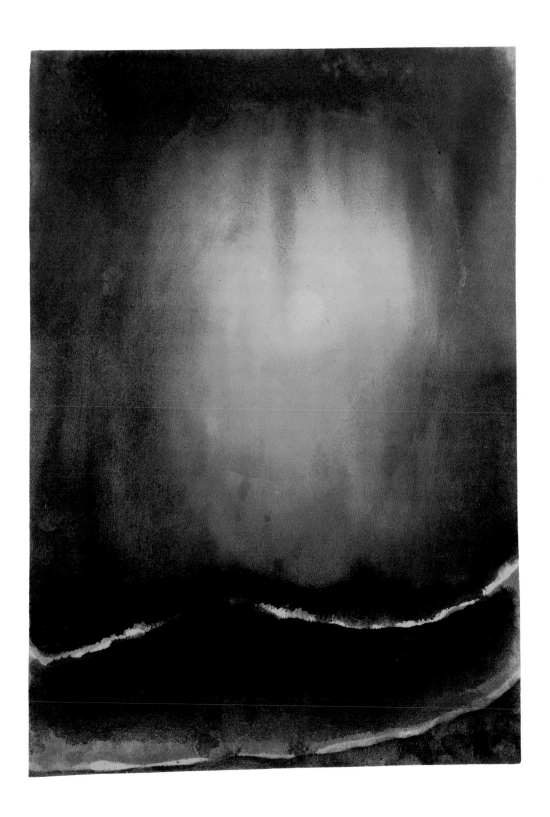

Plate 21
Dark Mesa
9 in. x 11.75 in.
Property of the William T. Kemper Foundation

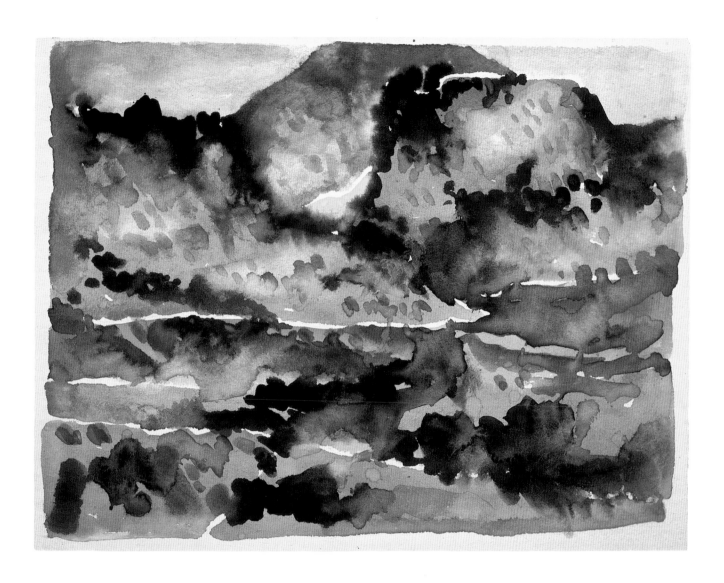

Plate 22
Light Coming on the Plains
12.5 in. x 9 in.
Property of Bebe and R. Crosby Kemper

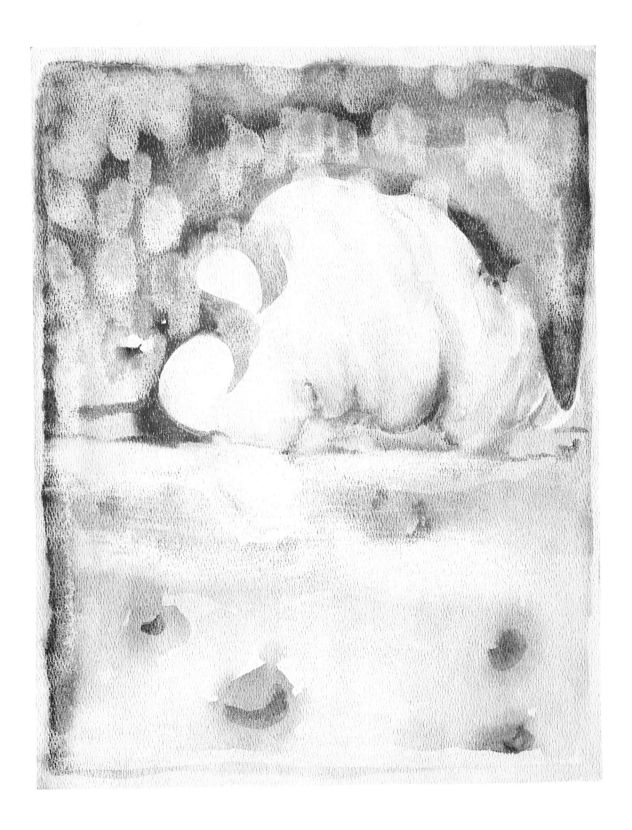

Plate 25
Autumn on the Plains
11.25 in. x 15 in.
Property of the William T. Kemper Foundation

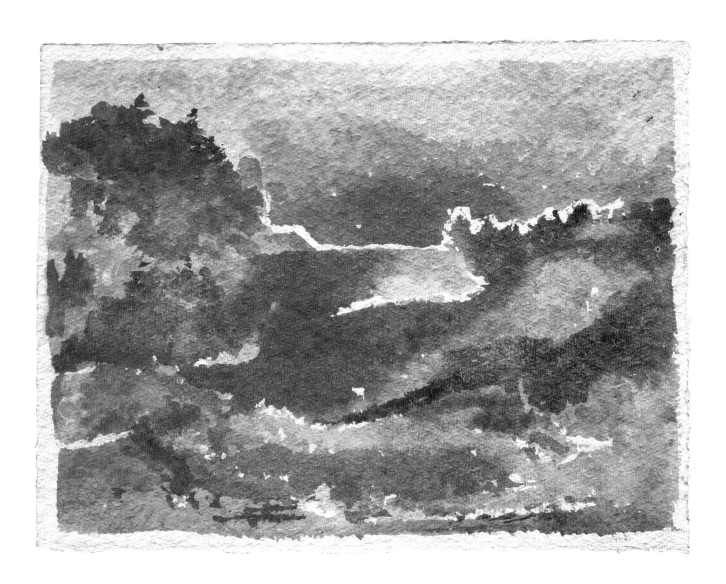

Plate 26
Purple Mountain
9.5 in. x 12.25 in.
Property of the William T. Kemper Foundation

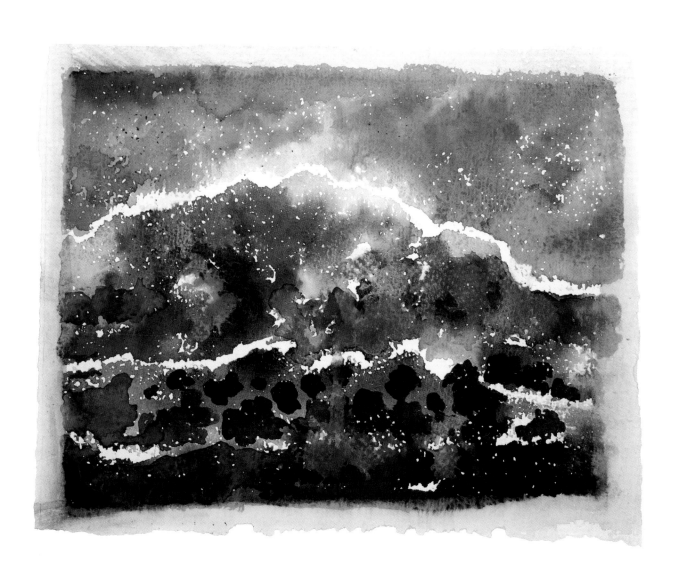

Plate 27
Dusk in the Canyon
8.5 in x 11.25 in.
Property of the Enid and Crosby Kemper Foundation

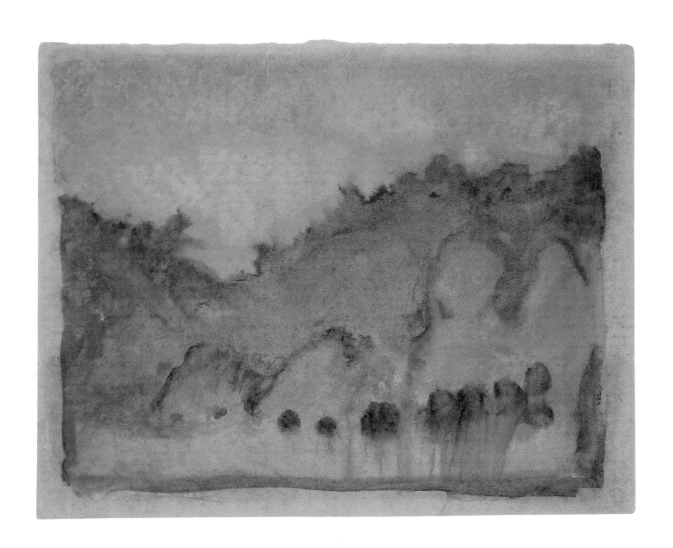

Plate 28
Sunrise
7.75 in. x 7.5 in.
Property of the Enid and Crosby Kemper Foundation

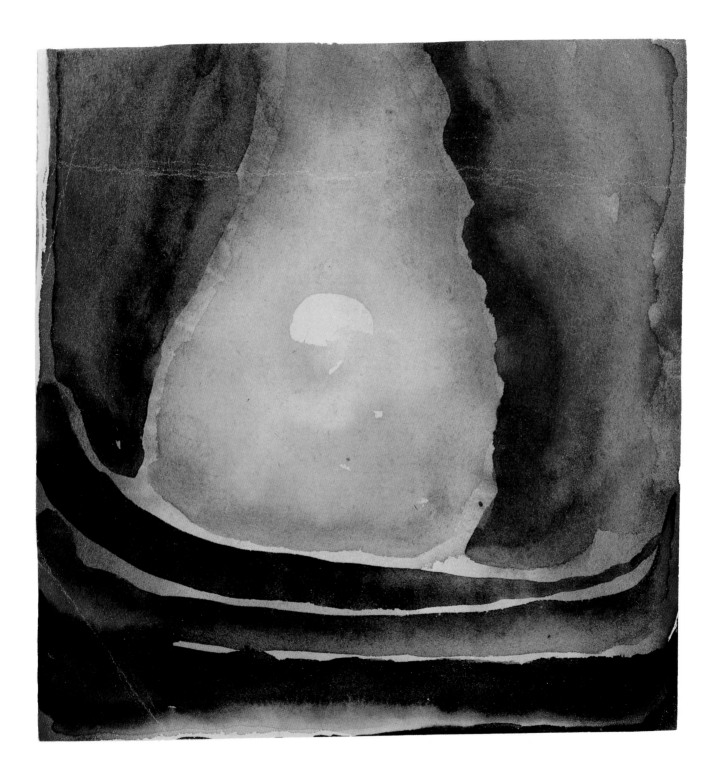

LIST OF WORKS
and
SELECTED BIBLIOGRAPHY

GEORGIA O'KEEFFE
CANYON SUITE

(Note: All works are watercolor on various kinds of paper paper and date from 1916 to 1918 unless otherwise indicated)

Plate 1
Evening
11.5 in. x 8.5 in.
Property of the Enid and Crosby Kemper
Foundation

Plate 2
Landscape
8.5 in. x 11.5 in.
Property of the Enid and Crosby Kemper
Foundation

Plate 3
Across the Plains
10.25 in. x 14.75 in.
Property of the Enid and Crosby Kemper
Foundation

Plate 4
Sunrise
10.5 in. x 7.5 in.
Property of the Enid and Crosby Kemper
Foundation

Plate 5
Standing Nude
12 in. x 8 in.
Property of Bebe and Crosby Kemper

Plate 6
Abstraction, Green & Red
9.5 in. x 12.5 in.
Property of the Enid and Crosby Kemper
Foundation

Plate 7
Abstraction, Dark
11.25 in. x 10.25 in.
Property of Kathleen and Gerald Peters

Plate 8
Abstraction
9.5 in. x 12 in.
Property of the William T. Kemper
Foundation

Plate 9
Tree
15.25 in. x 10.75 in.
Property of the William T. Kemper
Foundation

Plate 10
Portrait W
8.5 in. x 11 in.
Property of the William T. Kemper
Foundation

Plate 11
Canyon Landscape
9 in. x 12.25 in.
Property of the William T. Kemper
Foundation

Plate 12
Abstraction
12 in. x 9 in.
Property of the William T. Kemper
Foundation

Plate 13
Blue Hills
8.75 in. x 11 in.
Property of Kathleen and Gerald Peters

Plate 14
Abstraction, Black and Blue
12.25 in. x 10.25 in.
Property of Bebe and Crosby Kemper

Plate 15
Abstraction, Sunset
10.75 in. x 9.5 in.
Property of the William T. Kemper
Foundation

Plate 16
Abstraction, Pink & Green
7 in. x 10.5 in.
Property of the Enid and Crosby Kemper
Foundation

Plate 17
Red House / Fence & Door
10.5 in. x 7.5 in.
Property of Kathleen and Gerald Peters

Plate 18
First Light on the Plains
12.5 in. x 9.5 in.
Property of the Enid and Crosby Kemper
Foundation

Plate 19
Landscape with Crows
7.5 in. x 11 in.
Property of Bebe and Crosby Kemper

Plate 20
Sunset
11.5 in. x 8 in.
Property of Bebe and Crosby Kemper

Plate 21
Dark Mesa
9 in. x 11.75 in.
Property of the William T. Kemper
Foundation

Plate 22
Light Coming on the Plains
12.5 in. x 9 in.
Property of Bebe and Crosby Kemper

Plate 23
Gray Abstraction (Train/Desert)
9.5 in. x 12.25 in.
Property of Bebe and Crosby Kemper

Plate 24
Train Coming In
14 in. x 11 in.
Property of Kathleen and Gerald Peters

Plate 25
Autumn on the Plains
11.25 in. x 15 in.
Property of the William T. Kemper
Foundation

Plate 26
Purple Mountain
9.5 in. x 12.25 in.
Property of the William T. Kemper
Foundation

Plate 27
Dusk in the Canyon
8.5 in x 11.25 in.
Property of the Enid and Crosby Kemper
Foundation

Plate 28
Sunrise
7.75 in. x 7.5 in.
Property of the Enid and Crosby Kemper
Foundation

Related Works

*Georgia O'Keeffe
Yellow Jonquils #3
1936
40 in. x 36 in.
Oil on canvas
Property of the Enid and Crosby Kemper
Foundation

*Georgia O'Keeffe
Autumn Trees—The Chestnut Tree—Red
1924
36 in x 30 in.
Oil on canvas
Property of the William T. Kemper
Foundation

Alfred Stieglitz
Portrait of Georgia O'Keeffe
1920
Photograph
Property of the Enid and Crosby Kemper
Foundation

Alfred Stieglitz
Equivalent
1926 or 1929
4.5 in. x 3.75 in
Vintage silver gelatin developed-out print
Provenance: Estate of Georgia O'Keeffe
Bebe and Crosby Kemper Collection of the
Kemper Museum of Contemporary Art
and Design

*These works appeared in the exhibition *Georgia
O'Keeffe: Canyon Suite*, but are not a part of the
Canyon Suite.

Alfred Stieglitz
Equivalent
1926
4.6 in x 5.6 in.
Vintage silver gelatin developed-out print,
on original single-ply rag mount
Provenance: Estate of Georgia O'Keeffe
Bebe and Crosby Kemper Collection of the
Kemper Museum of Contemporary Art
and Design